Color Calming Colorful Animals

Calming Coloring Book for Cool Kids

Series: Freetobe

LORRAINE

Copyright © 2016 Lorraine
All rights reserved. No part of this publication may be reproduced, distributed, or transmitted in any form or by any means, including photocopying, recording, or other electronic or mechanical methods, without the prior written permission of the publisher, except in the case of brief quotations embodied in critical reviews and certain other noncommercial uses permitted by copyright law.

TABLE OF CONTENT

BIRD
CAMEL
ELEPHANT
GIRAFFE
HORSE
KANGAROO
GORILLA
LION
OWL
PANDA BEAR

BIRD

Birds can fly low and fly high, even sing and tweet

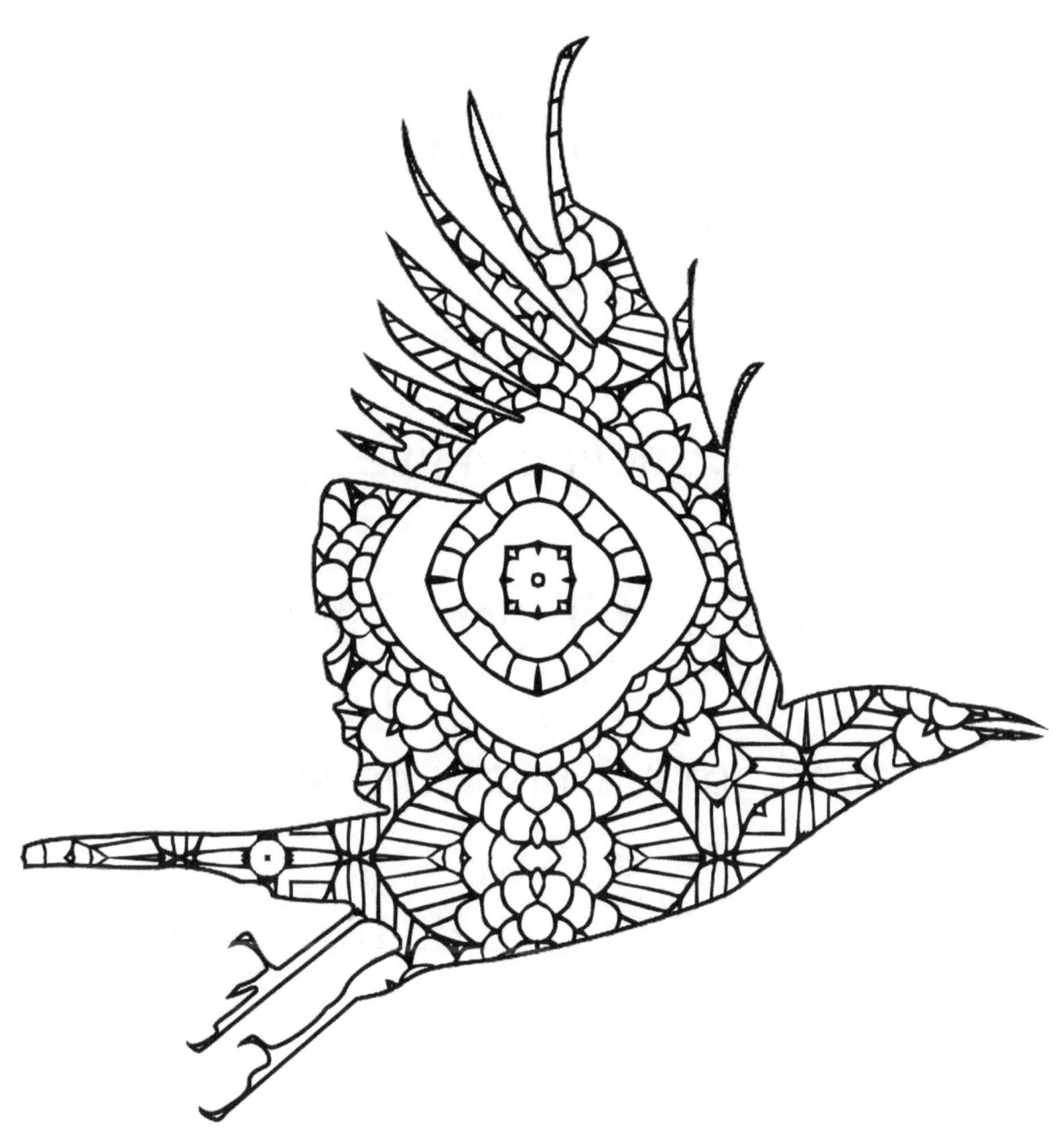

CAMEL

WOW! Camels can live up to 40 - 50 years. A full-grown adult camel stands 6ft. 1 in at the shoulder and 7 ft. 1 in at the hump.

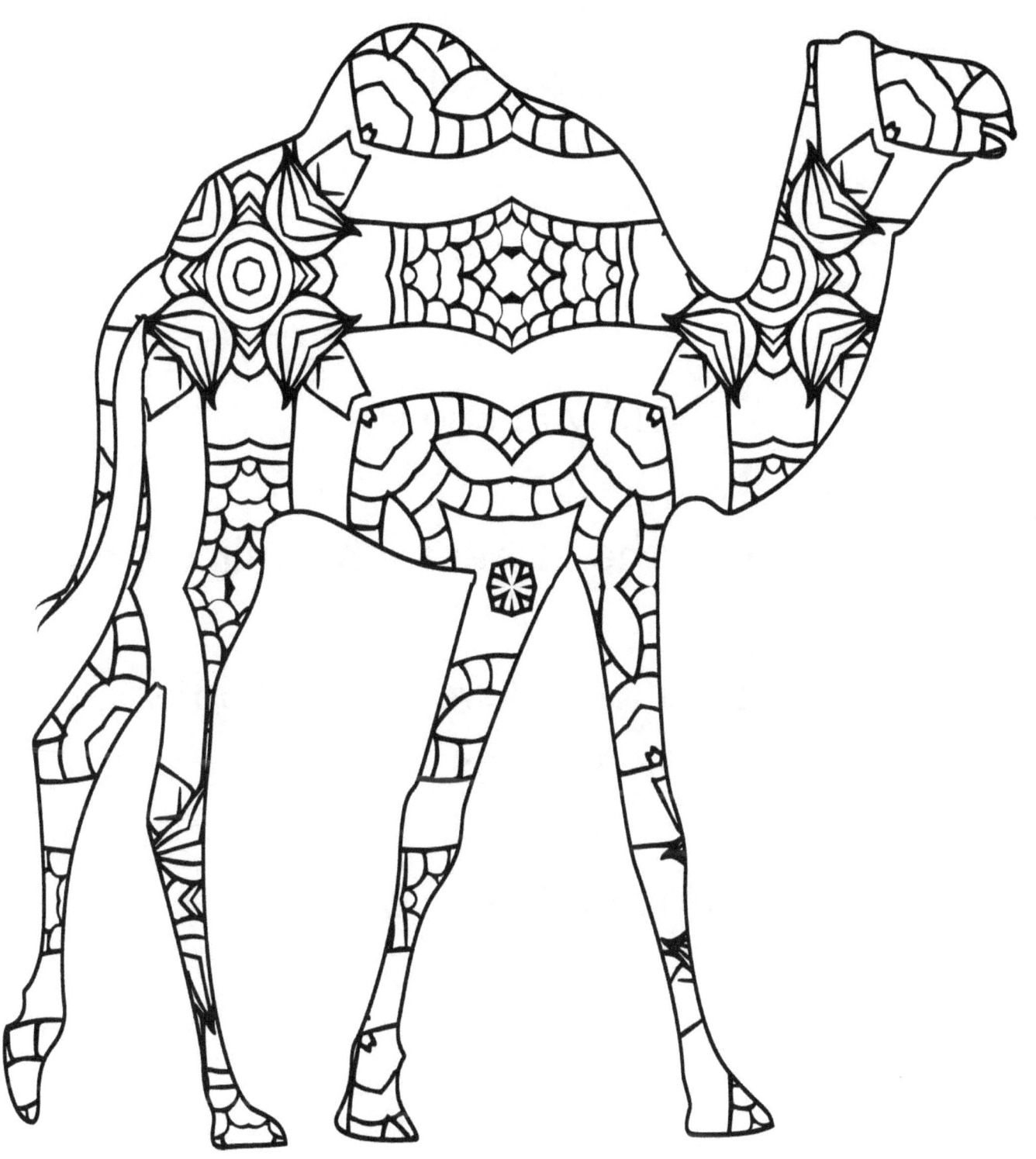

ELEPHANT

Did you know!

Elephants are the largest land animals on Earth. Elephants love to eat roots, grasses,

fruits and even bark.

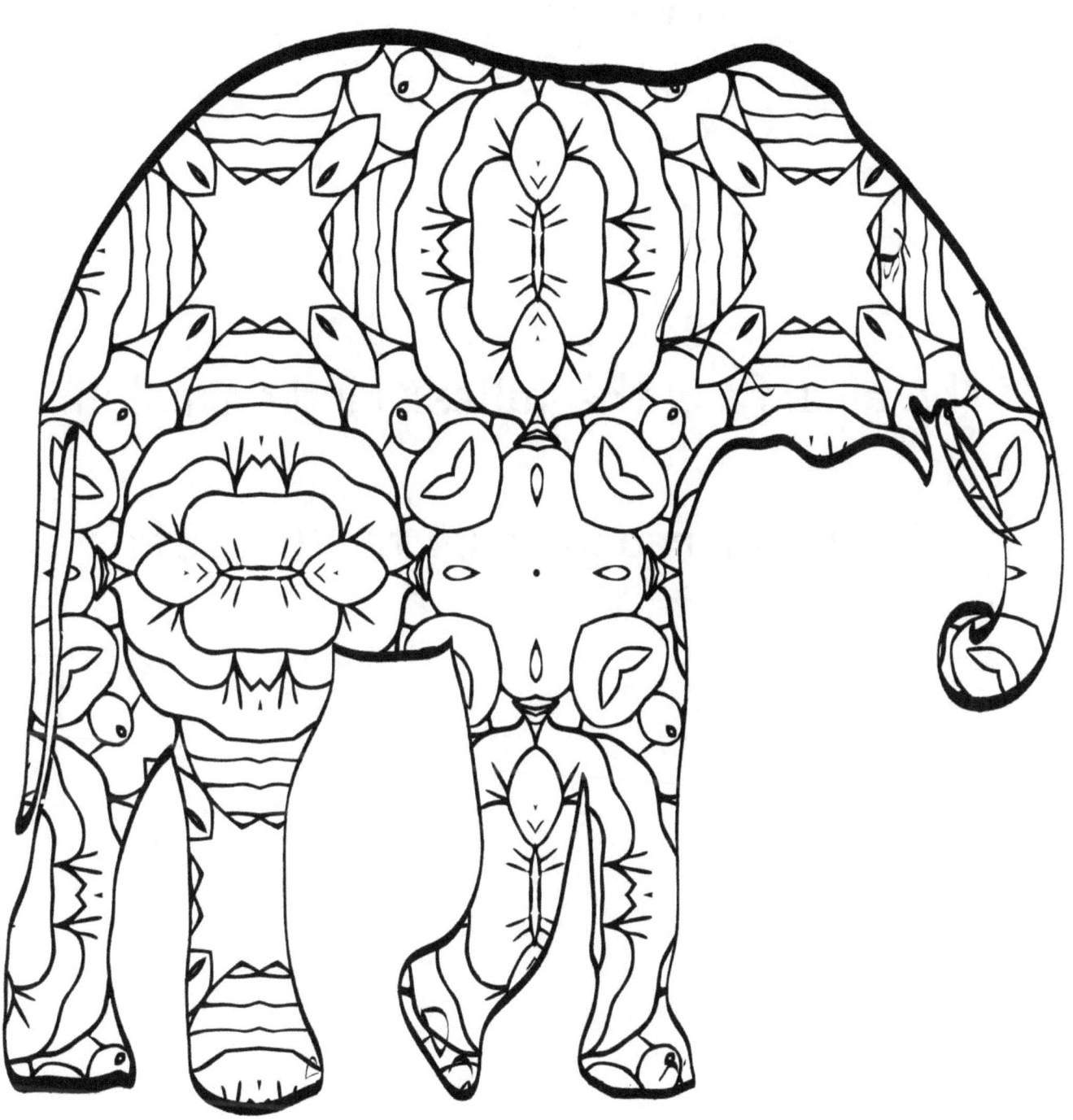

GIRAFFE

The giraffe is the tallest land animal in the world, reaching up to 16 - 18ft

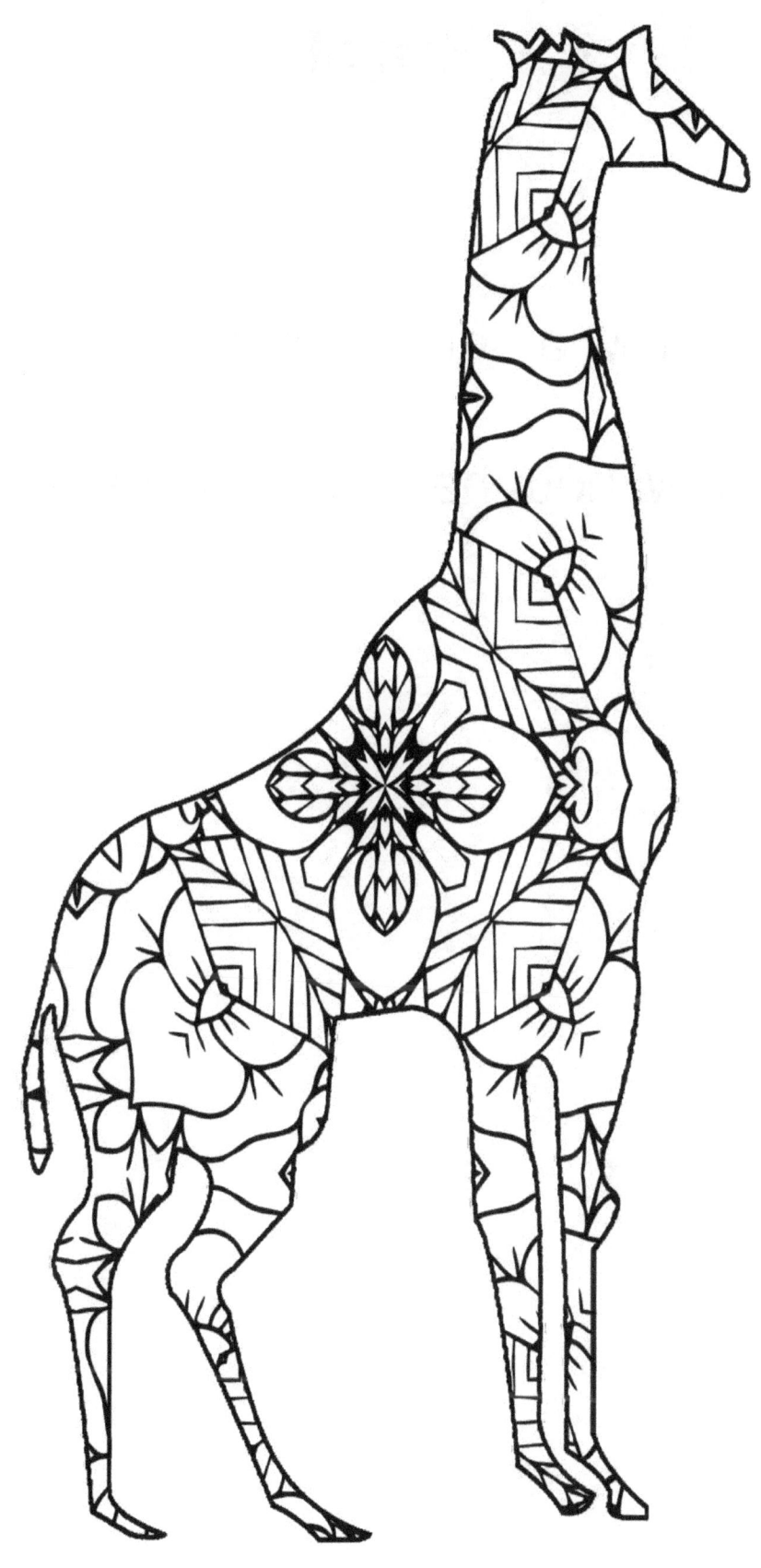

HORSE

Did you know, a horse can hear at 360° degrees, without having to move its head?

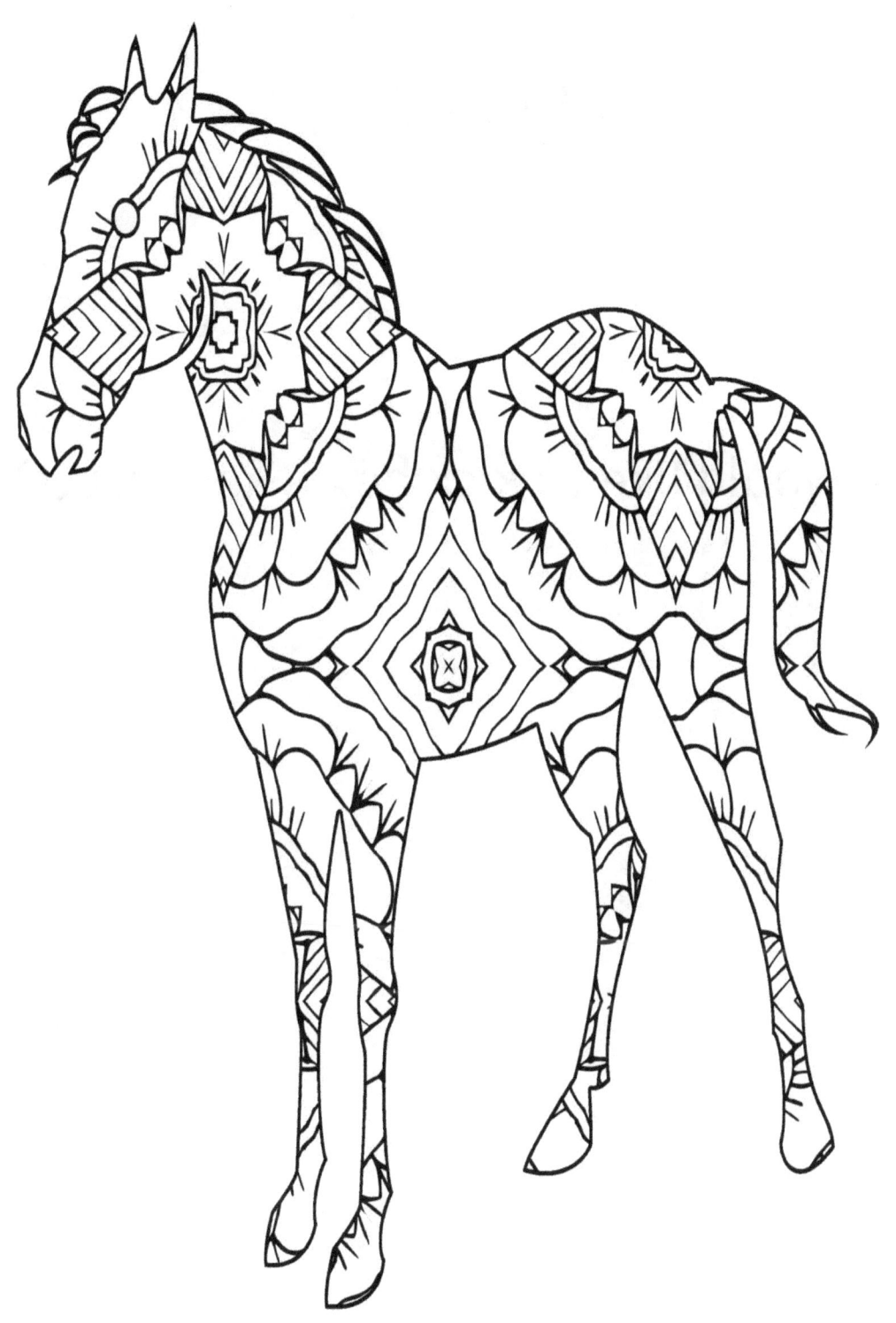

KANGAROO

How would like to kick box a kangaroo?

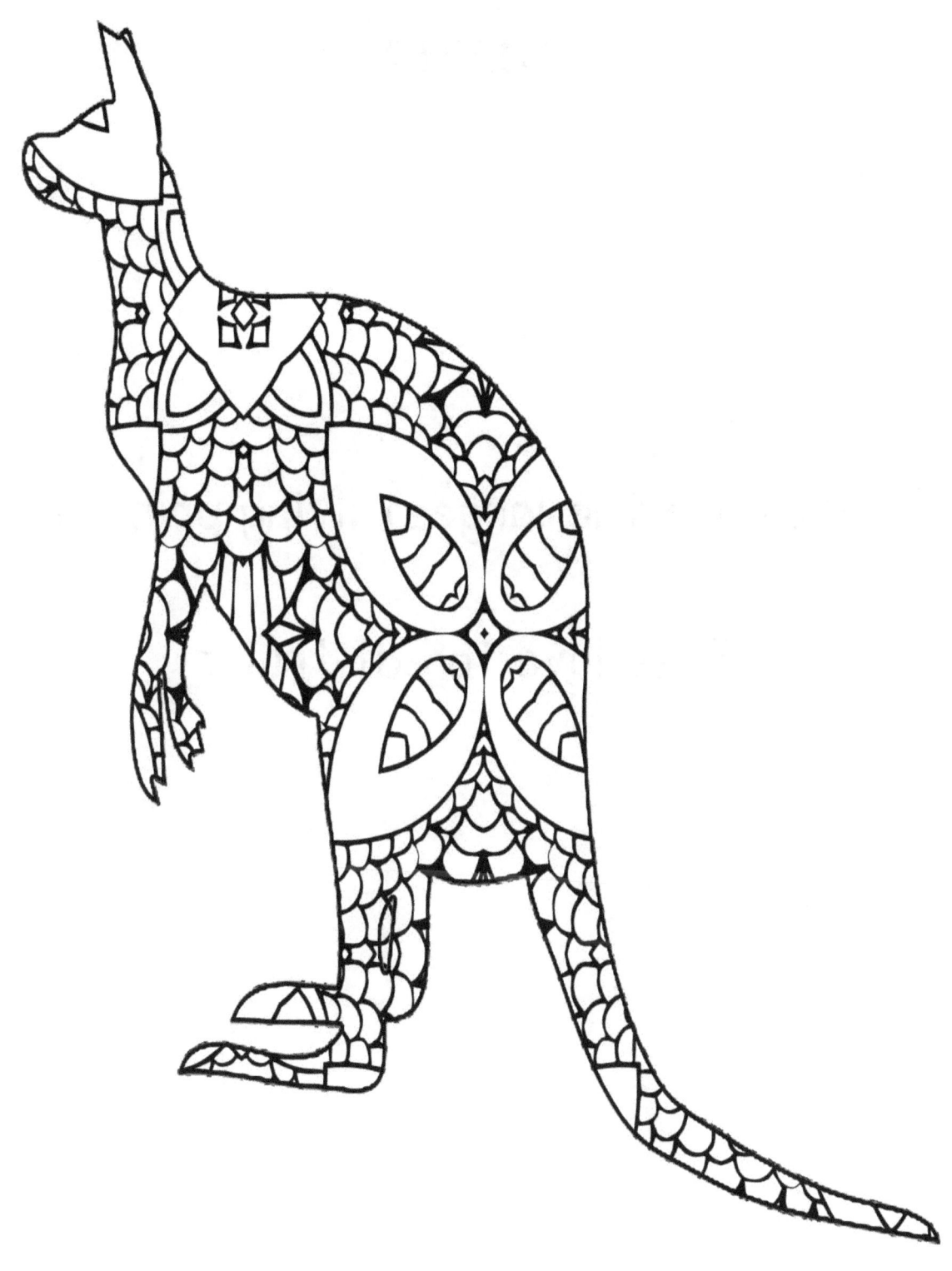

GORILLA

Gorillas are the largest living primates.

They love to eat fruits

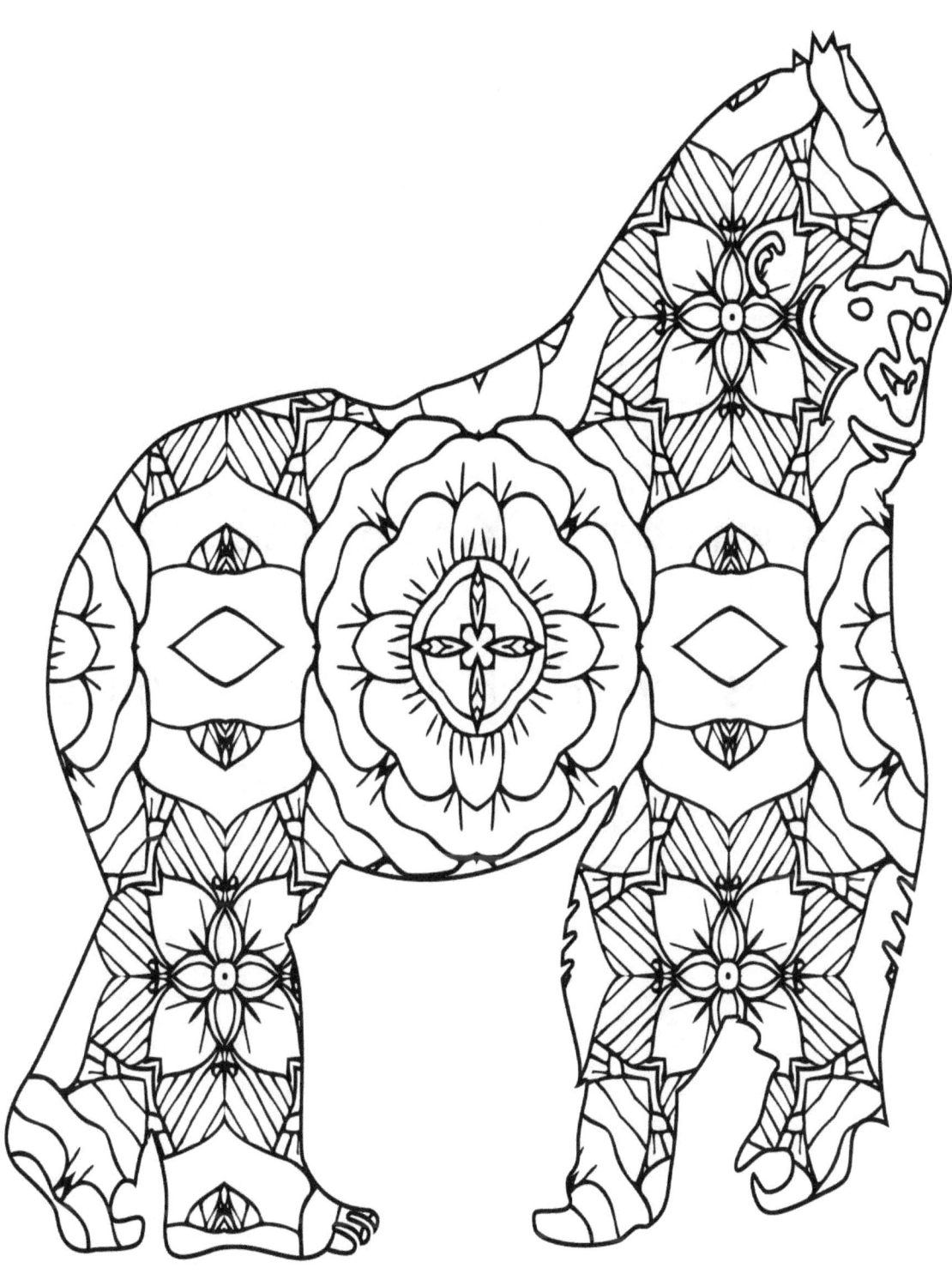

LION

Known as the "King of the Jungle"

Lions can weigh over 550 pounds

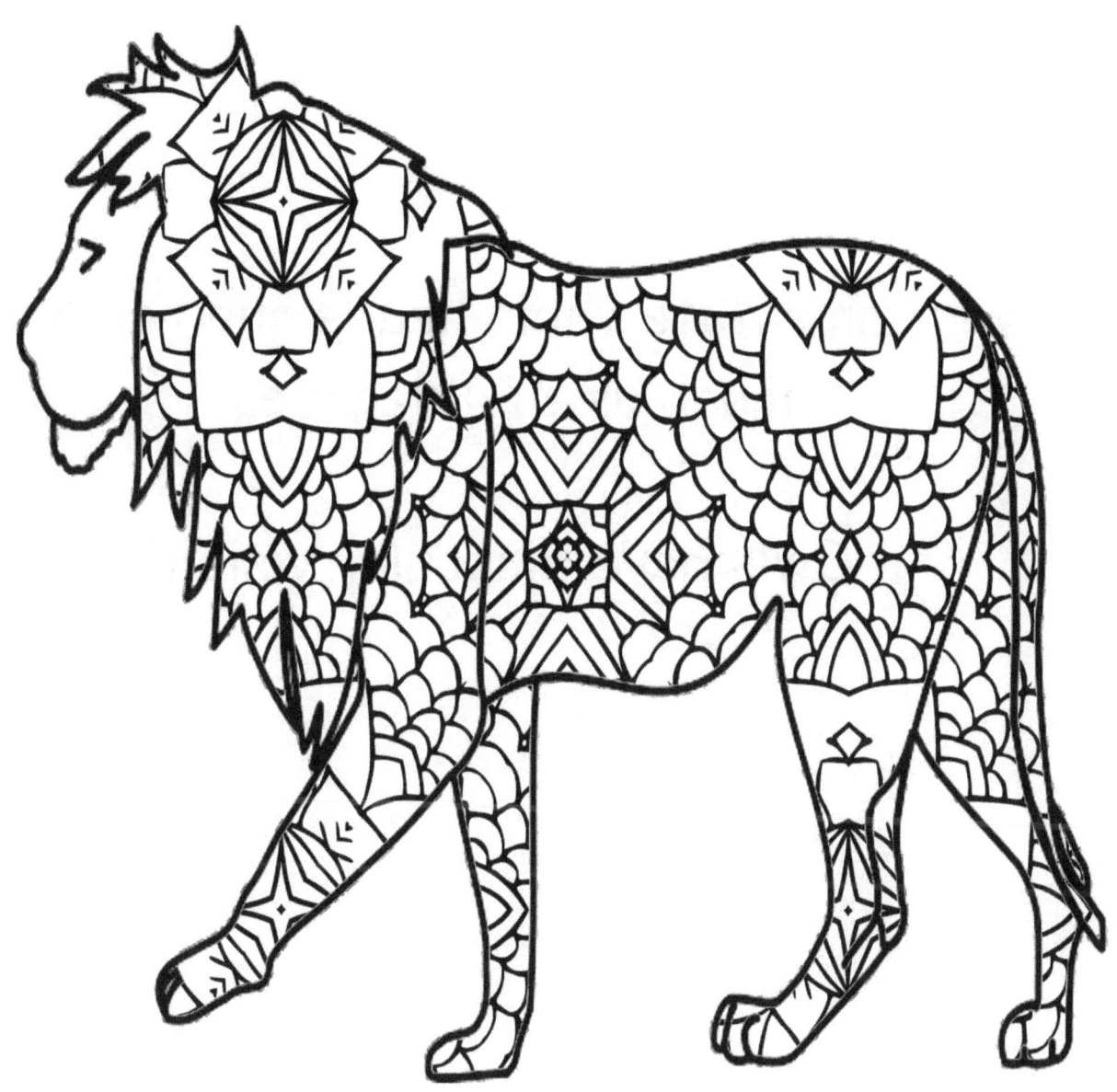

OWL

Owls can rotate their heads and necks as much as 270 degrees

Owls have binocular vision

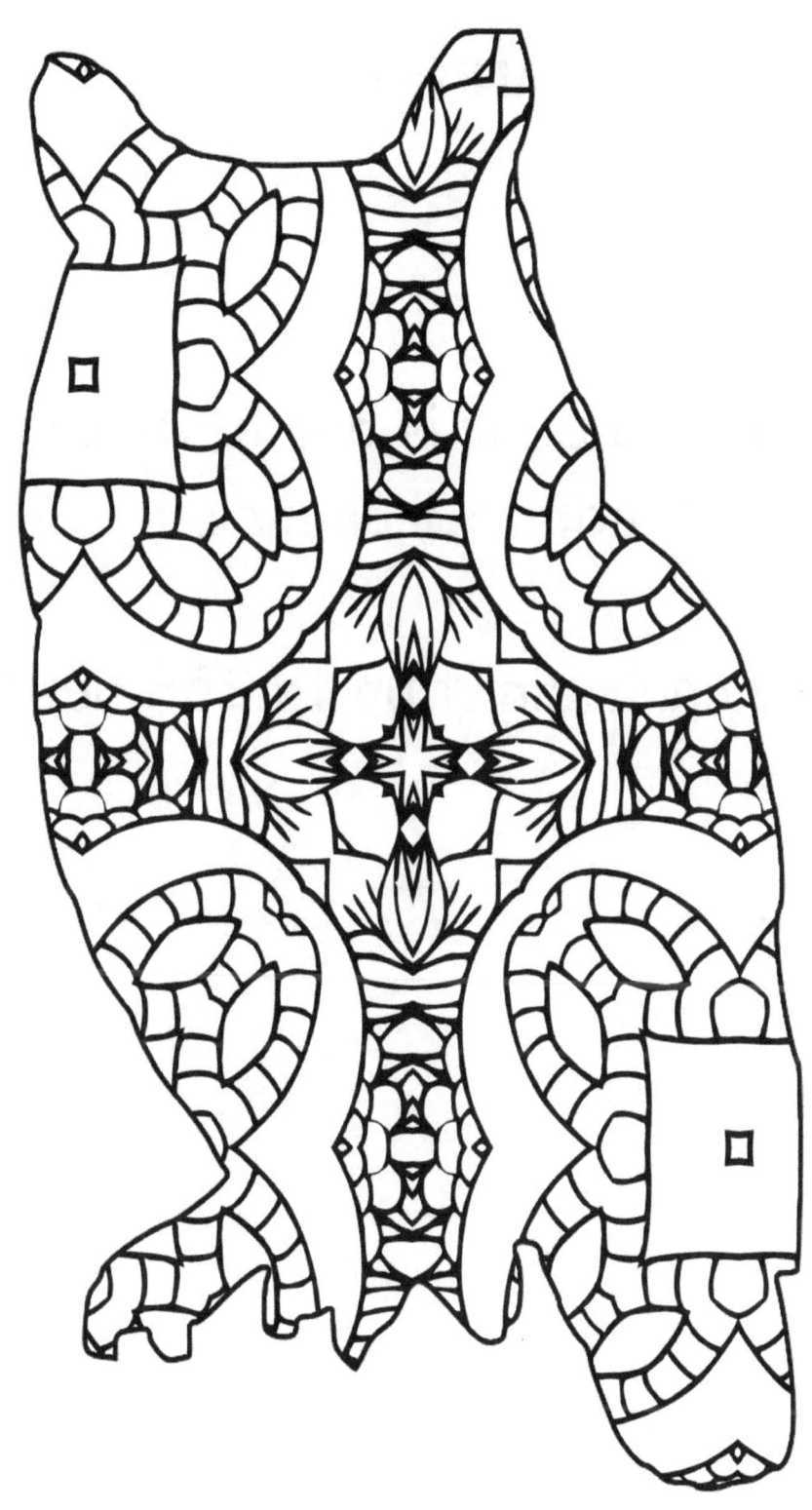

PANDA BEAR

The Panda Bear is one of the most admired animals

They can weight up to 256 pounds

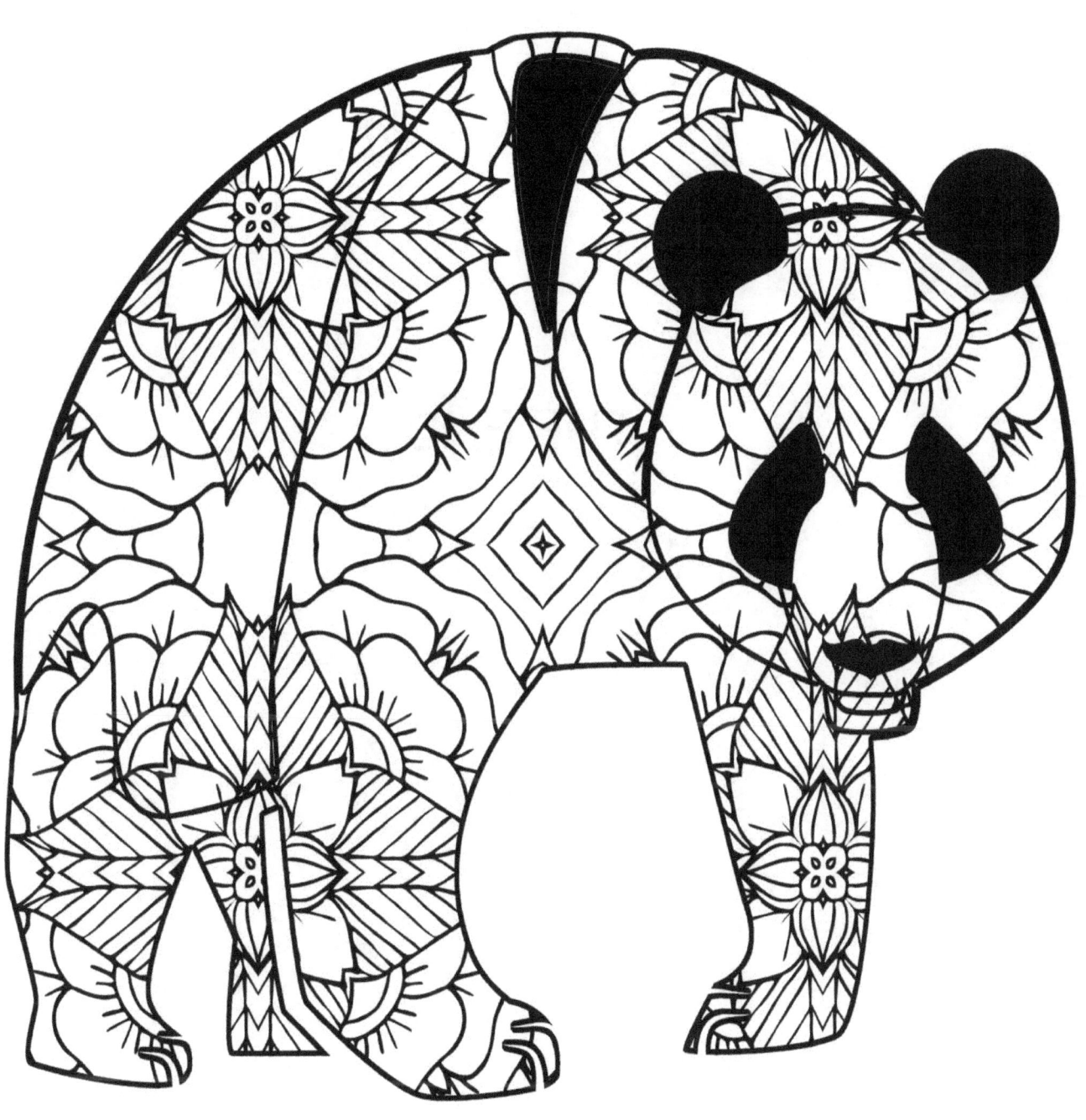

THE END

Freetobe series:

Lorraine
www.colormythoughts.com